DUTC
INTER

DUTCH INTERIORS

by
Sarah Lawson

Mid Northumberland Arts Group
1988

Copyright © Sarah Lawson 1988

ISBN 0 904790 62 2

First published 1988 by The Mid Northumberland Arts Group
Leisure and Publicity Department, Wansbeck District Council,
Town Hall, Ashington, Northumberland NE63 8RX

The Mid Northumberland Arts Group (MidNAG) is supported
by Wansbeck District Council, administered by the Leisure and
Publicity Department of the Council, and grant-aided by
Northern Arts

Designed by Sue Richards
Typeset by Joshua Associates Ltd, Oxford
Printed by Short Run Press Ltd, Exeter

Some of these poems have appeared in *English*,
the newsletter of the Anglo-Netherlands
Society, *The Pen*, *Quaker Monthly*, the *Times
Literary Supplement*, and *Poetry Introduction 6*
(Faber and Faber).

CONTENTS

View of Landscape: a Celebration 7

Dutch Interiors 8

Windy Morning on Schouwen-Duiveland 9

The Beach at Renesse 10

Westerschouwen Light 12

Hans and Anneke's Lakeland Terriers 13

Messages from the Harbour 14

The Harbour in February 15

Ice Skating in Brouwershaven 16

Breakfast in the Train Station at Goes 17

On the Oude Rijn 18

Carrots 19

Windmill 20

Spring in Friesland 21

Thinking of Captain van Swearingen in the Beemster 22

Old Masters at the Rijksmuseum 23

VIEW OF LANDSCAPE: A CELEBRATION

Only Holland looks not merely washed but ironed;
The pressed brown corduroy of March
Brightens into green by May.

The zig-zag dikes go mole running
Past white Maltese crosses
Primed to put the wind to work.

Always at half-swords with the sea,
The Dutch steal a whole new province from the waves;
Their generals are engineers
Filching land out from under the enemy.

It's not like other countries,
This land the Dutch invented.

Too pretty to be lived in, the houses
Are scrubbed down by the light
Rolling in like weather off the sea.
Trapezoidal roofs the shade of flowerpots
Make every house a House of Orange.

DUTCH INTERIORS

The cobbles winding like a cowpath
Toward the market square
Are a dike-top doing double duty
As a street and a corridor
Past works of art. At night
The Dutch interiors hang behind the glass.
New Vermeers and Steens: card-players lean
On tables topped with fringe-hemmed ruglets;
Overhead a bell clangs quiet light.
Every street is lined with lit-up dioramas
For passers-by to share,
As though the street has been impoldered
Into living rooms. Behind the proscenium hedge
Growing on the window sills
The family is a display team of domestic life.
The wind in our hair,
We pass along the windows
Like guests at a deaf-and-dumb houseparty
Welcomed but unacknowledged by the hosts.

WINDY MORNING ON SCHOUWEN-DUIVELAND

The wind is testing the trees this morning—
It sorts through the leaves
And throws out the loose ones.

The mountain ash
Is a wedding guest
Flinging confetti everywhere.

The towels lie under the clothesline,
Tossed off like a dancer's skirts
As the tempo quickens.

Still on the line,
Frantic shirts backstroke in place,
About to drown in a weir of wind.

THE BEACH AT RENESSE

The long stairway over the dunes
Is a stile for giants.
I count the fifty-eight steps
On the landward side
As we creep up it
Carrying our seats and lunch,
Our swimming suits and caps.

Then we sit by the sea
In the chairs we have brought
Where the edge of the water
Curls into white lace.

Behind us the stairs carry bathers away
On a high wooden wave
Over the dunes green with long-rooted plants.
They are little bright figures,
Quattrocento on a Jacob's ladder
Up to a fresco sky.

Closer bathers stand in the sea
Waist-deep or less
Looking for a dime they've dropped.
They watch those stringy toadstools
Resting like spit in the water.

In the low shadow-throwing sun the beached jellyfish
Are smooth like rounded, dying ice cubes
Left in the bottom of the glass.
The blue ones that sting,
Indelible splotches from a poison pen,
Lie dead and harmless, little globules
Of what makes the girls shriek,
Shrill and squeamish in bikinis.

WESTERSCHOUWEN LIGHT ———

By day the lighthouse is a barber's pole
Where the sharp surf shaves the dunes.
In the dark it doles out light, one radius at a time,
Wasting half of it on the land.

This cop on his beat
Makes the thieves duck
Twelve times a minute.

Westerschouwen Light,
Every time I catch its eye
It looks away.

HANS AND ANNEKE'S LAKELAND TERRIERS

'Weet je niet? Weet je niet?'
Say the paws of the dogs all day on the floor.
Their frilly, furry pantalettes prance
To staccato tap dance cleats
(*'Weet je niet? Weet je niet?'*)
Across the hardwood floorboards.

In the tired evenings the terriers lie
By the foot of the floor lamp
Like a pair of little brindled bolsters
Tossed down from the corners of the sofa.

MESSAGES FROM THE HARBOUR ———

The deserted harbour is crowded with noise.
The boats in their off-hours fill the air
With derisive messages for the inland towns.
The wind loses them along the way, of course,
Like careless boys made to bear reports
And dropping them behind the barn,
Among the trees.
 The ironic ropes
Slap the hollow metal masts and mimic cowbells
To taunt the leeward inland folk.
A rush of hemp applause claps quickly
On other masts. The yachts all celebrate each other,
Exchanging little bows.
 Some spirit of the yacht
Wants out. The sails are bound down
And four ropes hold each boat
Like a bull being taken to the fair.
The harbour is a riot of tin cups
Banged against the bars.
'Out! Out!' chant the maddened cables on the masts.
But clamour and riot however much they like,
The message does not carry far beyond the dike.

THE HARBOUR IN FEBRUARY

The harbour still rattles like the height of summer,
Now when the harbour basin's nearly walkable.
Like slim horses nervous in their stalls,
The yachts shy a little on their tethers
And keep some real water to be restless in.
The next week, though, is quiet with ice,
And the over-wintering boats are caught solid,
Motionless where they fidgeted in their narrow moats.

ICE SKATING IN BROUWERSHAVEN —

Over the formal white-gloved trees
The windmill pokes its clockwork rabbit ears
Just too far away to hear the skaters' oom-pa.
They flooded the old playground,
Inviting Jack Frost to run through it.
He came one night and hung around the place
Until half the town had red noses
From skimming counter-clockwise
Under the dim winter sun,
Dark figures on their annual slick sharp shoes.

Van Dam clears the frozen sawdust
Off the rink, letting the motored bottle brush
Pull him along like a sleepy water-skier.
Behind him like gulls in a tractor's wake
Little boys pick over the new ice,
Dark in brush-wide swathes.

Beyond the range of toy Alps at the edges of the rink
The hot chocolate van is mobbed by stocking caps
All wagging their tails. Flat-footed wallflowers,
Transmontane, watch the others dance;
Still on the far side of the harbour
The uninvited mill strains for a polka phrase.

BREAKFAST IN THE TRAIN STATION AT GOES ──

In the early morning fog
Everything looks unscrubbed.
The bus lights cast grey megaphones in front,
Shouting in mime that they're on their way.
The fragile bicycles are all fog
Between the white light and the red.

As I drink my coffee by the window,
In from the doorstep dark comes the day
With a huge bouquet of purple iris
Filling the sky. When I leave
The flowers have faded to lilac
And the day is rolling up its sleeves.

ON THE OUDE RIJN

Grebes nesting under the waterfall of willow
Watch our boat from behind their suburban curtains.
We chug on past the rugs of woven water lily leaves
Set out on the river like saucers in the sun.

Down beyond the sluice we turn
To cruise back through the afternoon.
We tie a knot in the wake we tow,
Like the corner of a handkerchief for remembrance.
The loop unravels as we spurt away
And sinks into the green June water,
Down to where all the old wakes lie.

CARROTS

An extra roof
Lies among the farm buildings,
Orange and pitched like the others,
But covering only the farmyard grass.
It is October now
When the tractors scuff their dirty boots
Down all the country roads,
And the waggons haul in sugar beet
And carrots, orange as tile,
Heaped among the barns and sheds.

WINDMILL

The wind breathes on these sails,
Feeding the teeth of one wheel
With those of another.

Creaking like a canvas-loaded clipper,
The factory and the machine are one;
The building works as hard as anybody else.

Now the grindstones digest the grain,
Driven by generations of cogs
Forwarding messages from the wind.

SPRING IN FRIESLAND

You give me your memories
In the ribbons and wrappings
Of a birthday-festive farmhouse.
I walk through your youth,
Admiring everything,
Like a visitor on a day
When the public's not admitted.

The tulips on the windowsill
Bend graceful goosenecks toward us,
Straining to hear
What makes us laugh together so.

THINKING OF
CAPTAIN VAN SWEARINGEN
IN THE BEEMSTER

They made the water lie down
And play dead.
Now the houses step in unison
Over their moatlings
On the way to the street.

I come to the Beemster
Thinking of the old captain,
A distant forebear, who sailed here
Until they drained his seaway
To make more of North Holland.
I look at the sky, which even the Dutch
Can't control. He would recognize that
And the clouds' moving, changing mountain ranges.

All these houses lie on the old sea bottom,
The church spire showing like a periscope
Above the surface of the captain's sea.

OLD MASTERS AT THE RIJKSMUSEUM ———

They have preserved just the most transient things in the
 house;
The strum of the lute, even the fish still wet from the
 pump,
And the apple core before the maid picked it up.
The checkerboard floor converges on the past.
They've painted the conversation almost overheard
Through the gauze of three hundred years,
The music-master's advice nearly caught,
The churchwarden's tuft of smoke,
The hand of cards one candled night.

Now you cannot find their graves,
But they still laugh; their lives go on
Against these hessian walls,
Merriment for these five lifetimes laid end to end.